Flower Fantasy
Adult Coloring Books

Color Art Designs

Introduction

Many adults say that they color to relieve stress. But for some coloring is more than that. For some coloring helps them to recover their fine motor skills. Adults with fine hand tremors say it really assists them to concentrate and therefore shake less.

Coloring can help you focus better. During the act of coloring an image you're so engaged in the immediate task that some say they are able to cope with uncomfortable feelings of anxiety.

Experienced colorists say coloring has really brought out their creative side and they are very proud of their completed creations. They are sometimes surprised at all the complements they receive after a completed piece.

So regardless of the reason you color make it fun. There's such a wide variety of books to choose from that you will find something you like. There are patterns, swirls, mandalas, modern and vintage styles. So what are you waiting for? Grab this coloring book and color away!

Tips for Coloring

"Flower Fantasy" is a book mainly for adults new to coloring. Some Adult coloring books can be very detailed. They have extremely small areas to color. This is great for the experience colorist. But for a novice that could create stress. The last thing you need is to get upset while you color. You are trying to relieve stress!

The images are on one side of the page. So if you decide to use markers the bleed would not be such an issue.
You can use markers or pencils. Buy an economical set of each and see which you prefer. Some swear by Sargent colored pencils others by Pentel pens. Everyone has their favorite. You'll soon have yours too.

In this book you will find a variety of images from different artists. Some of them were hand drawn others were not. The images are not all alike because artists specialize in different styles. But you can be sure the images were chosen with a newbie in mind.

So look through your book. Try the easy ones first. Leave the more detailed ones for later. It's your book. Color the way you want. Add a little touch up or some doodles in the white space if you want. There's no right or wrong way to color. Just color as you please.

Relax and have fun!

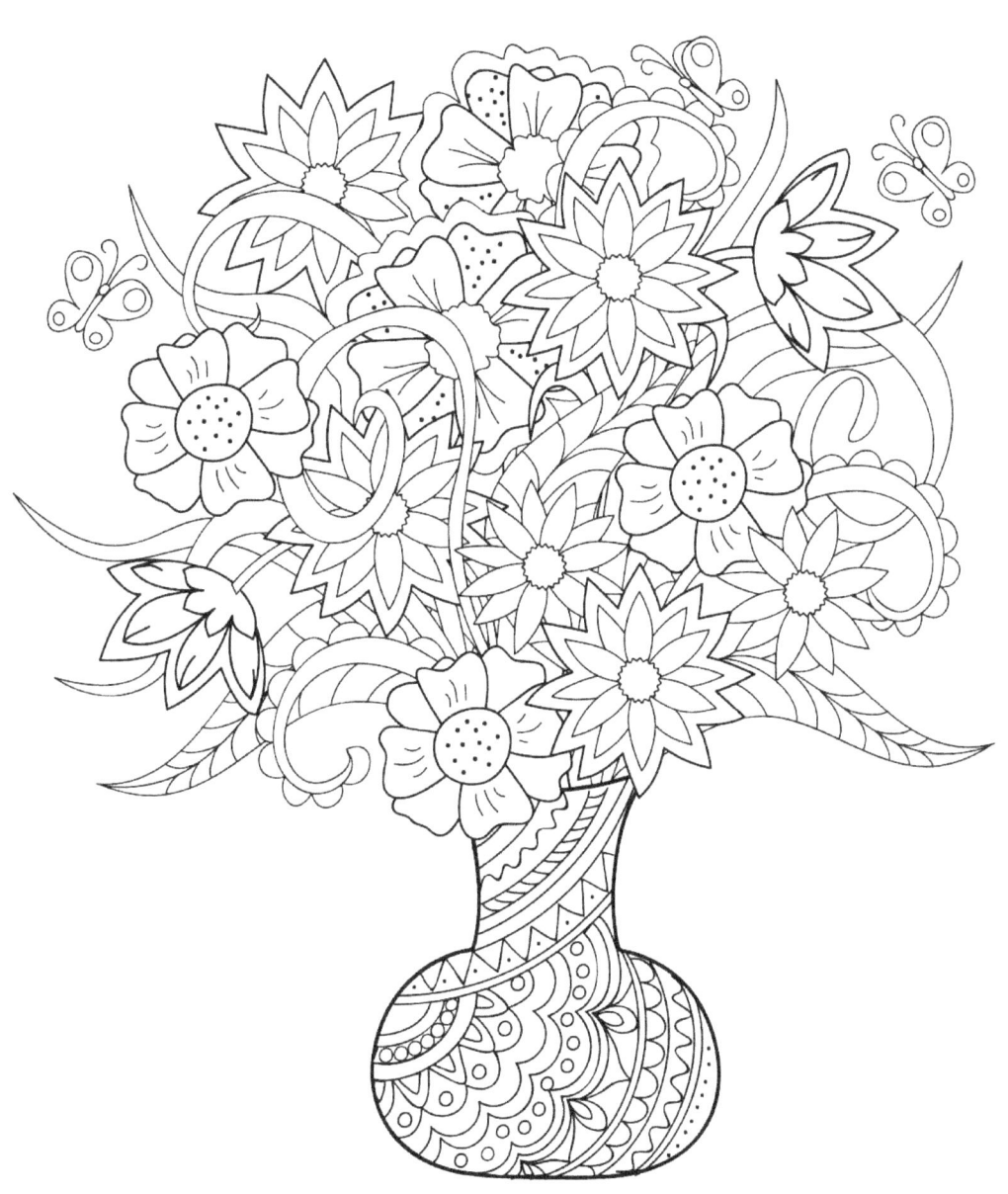

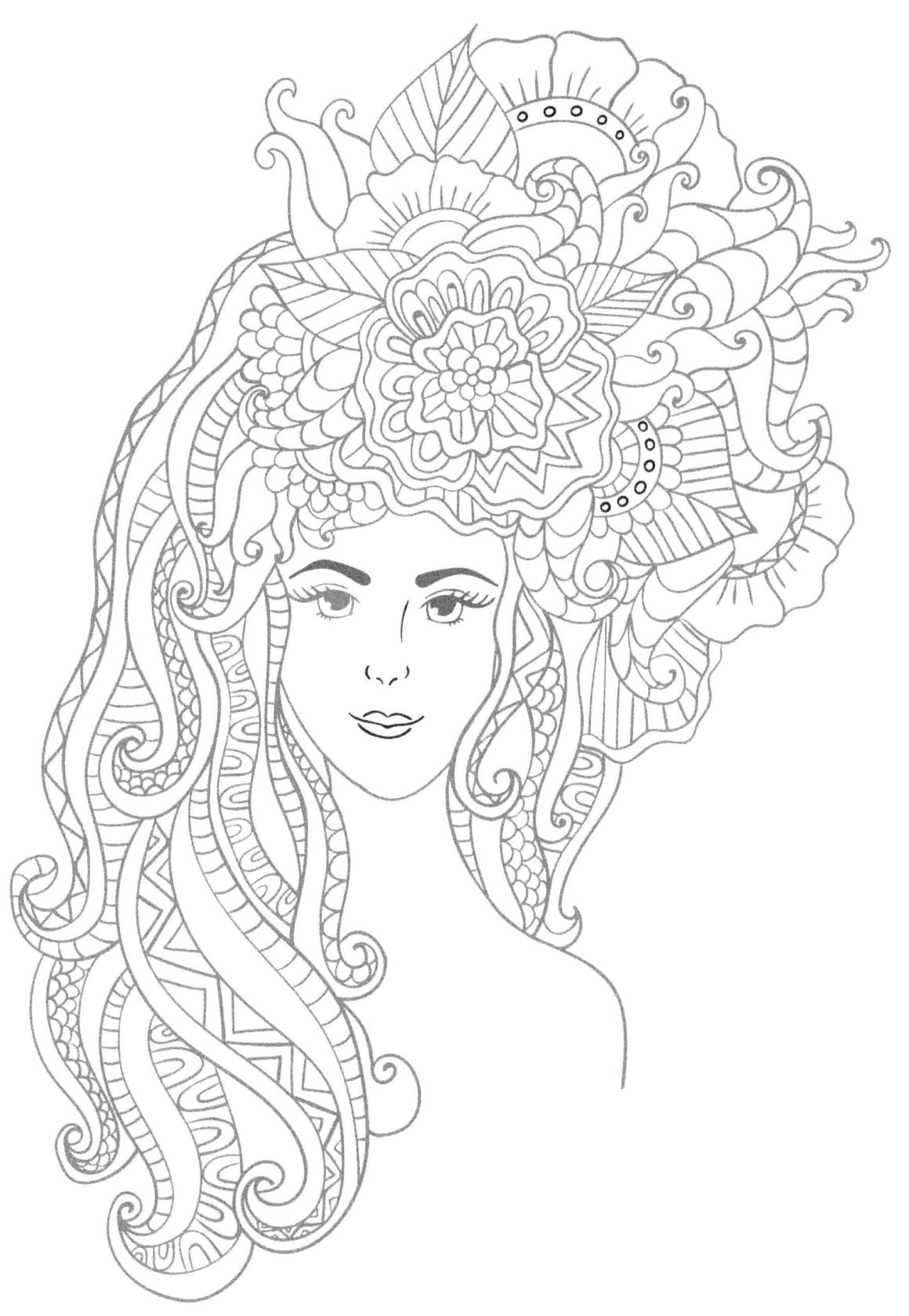

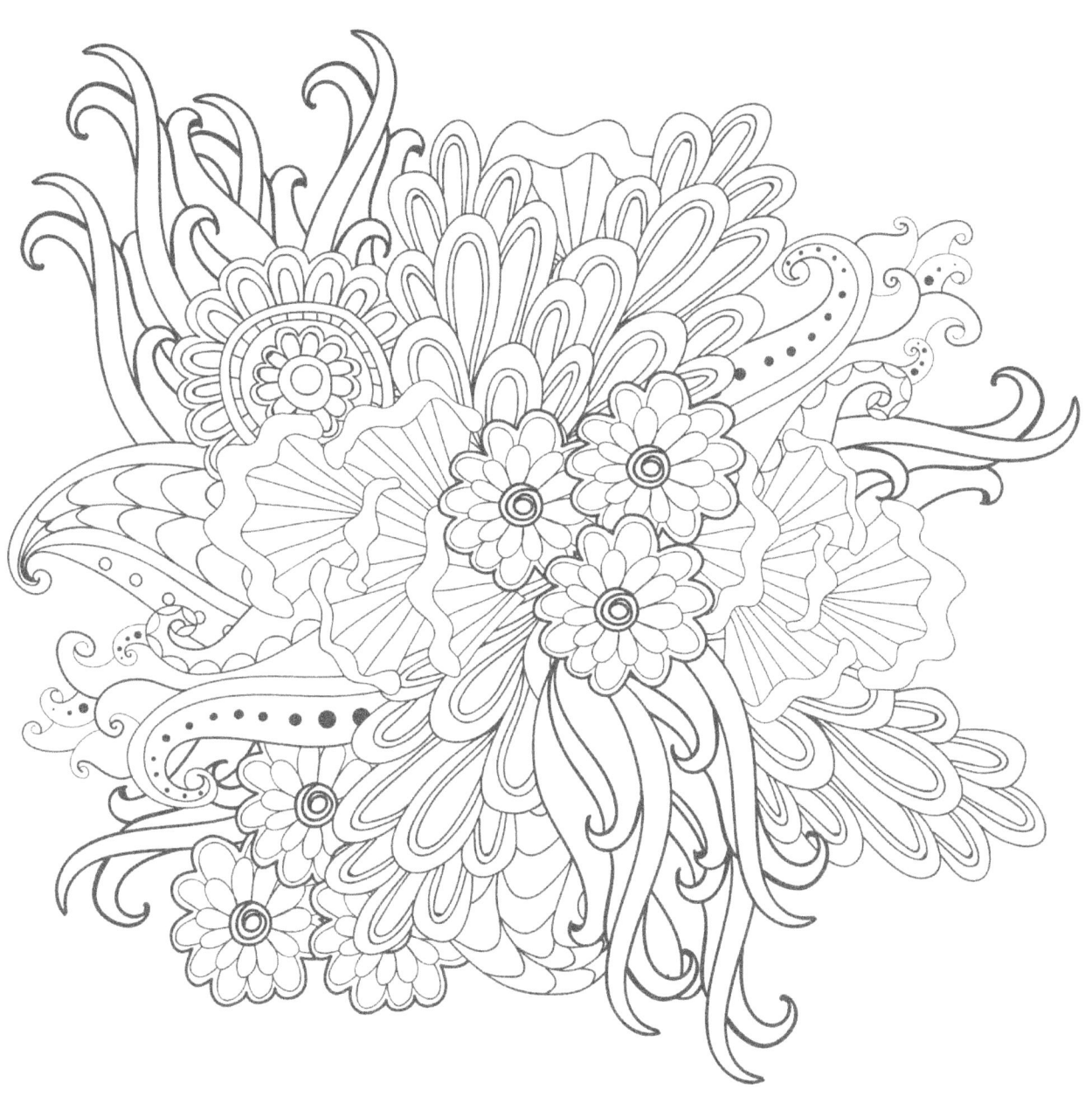

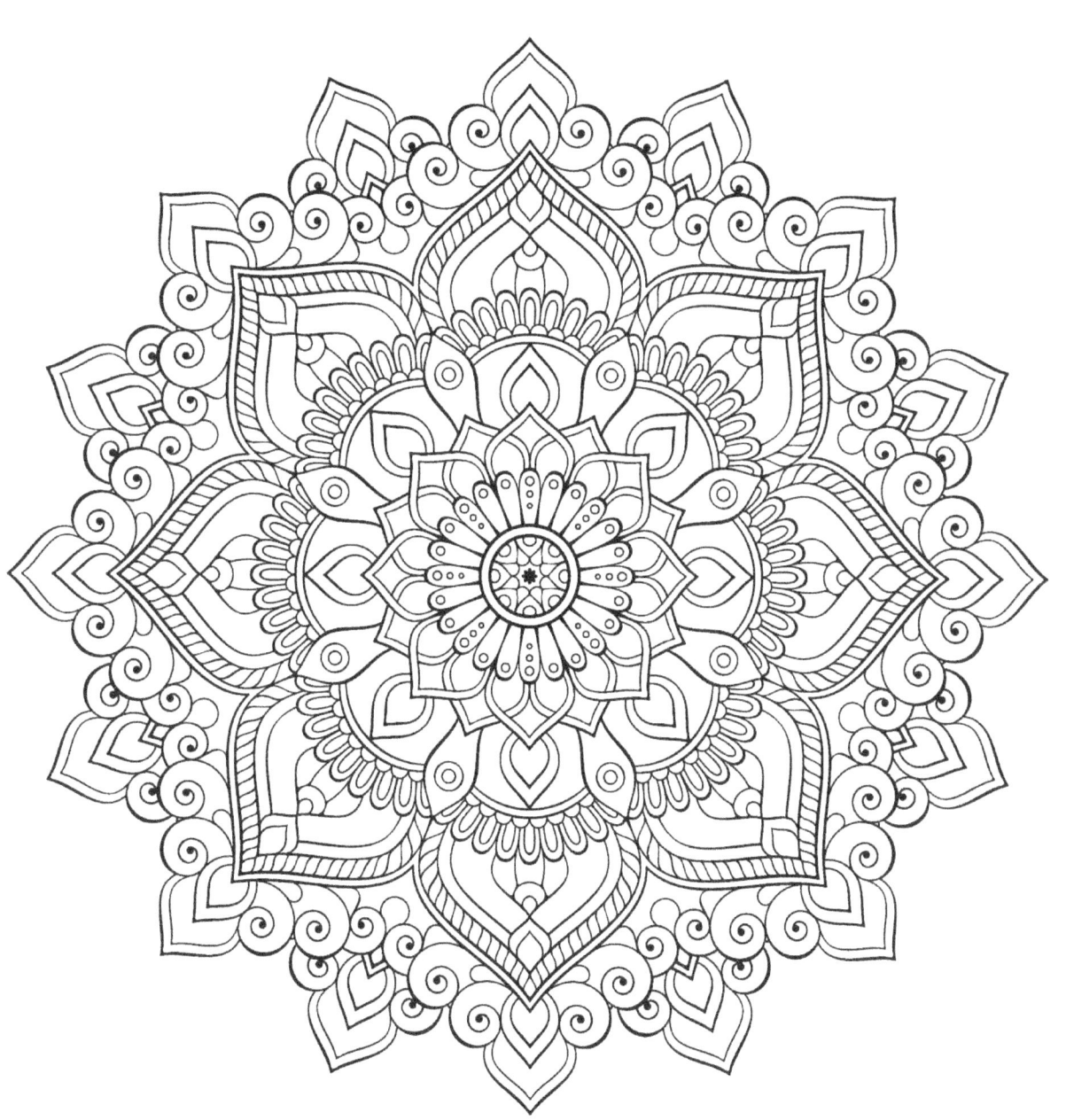

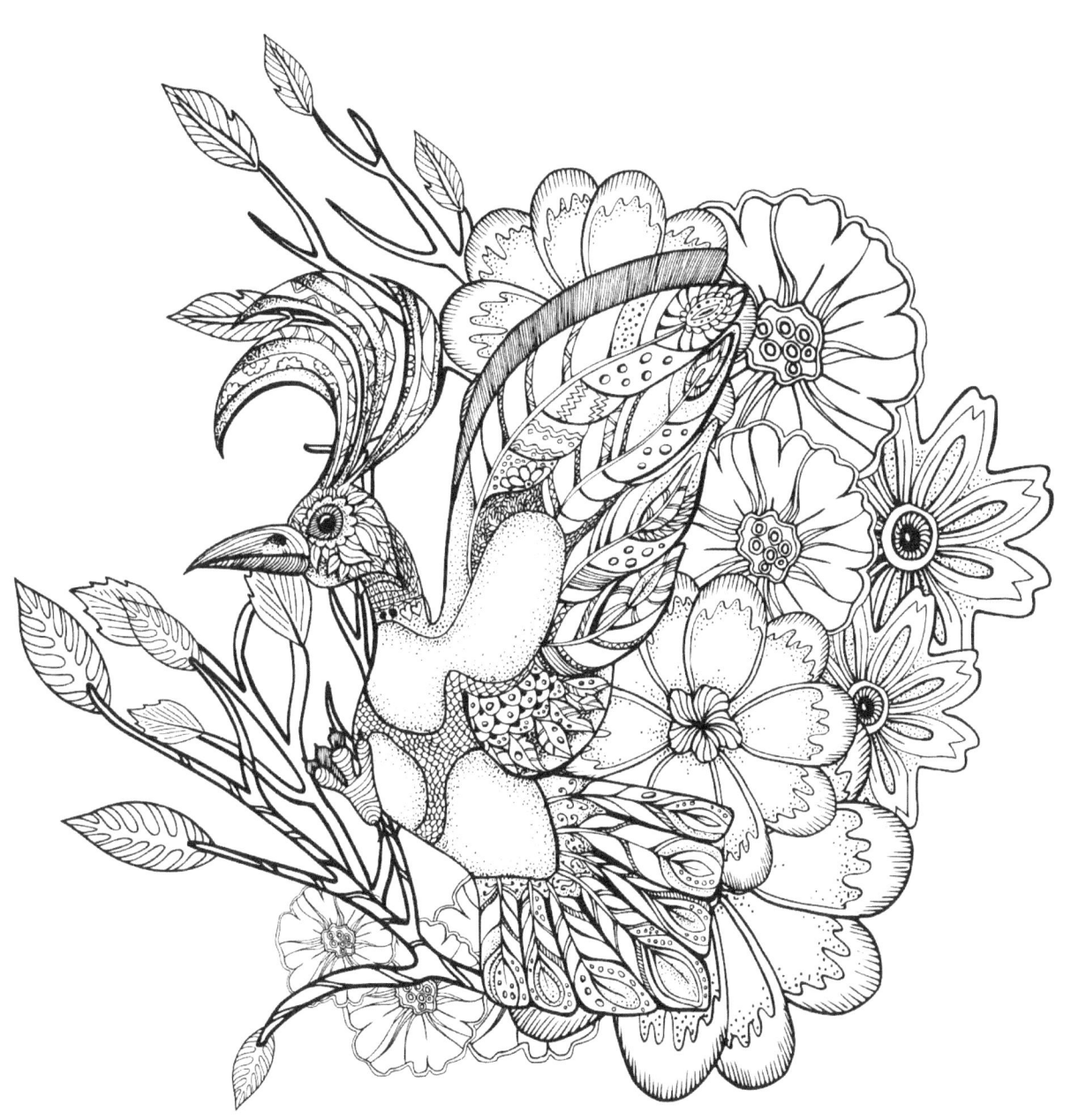

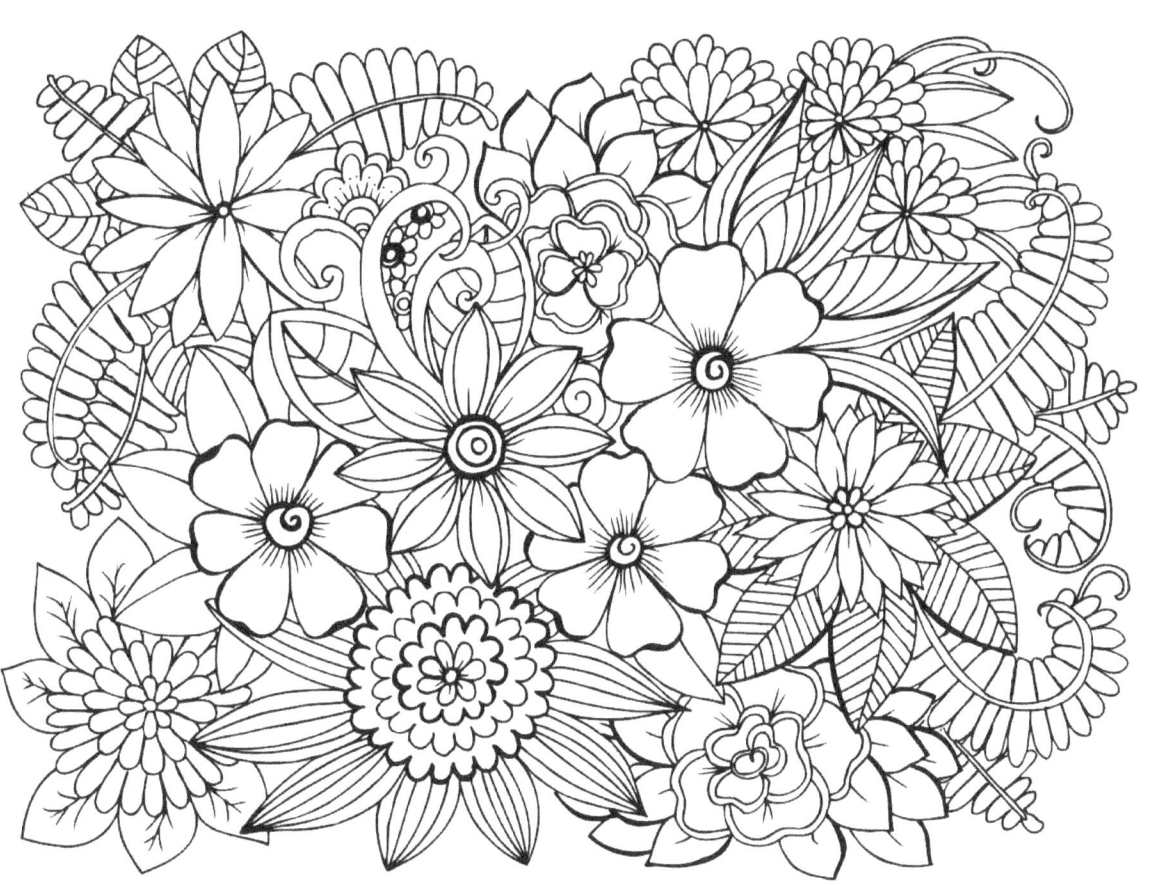

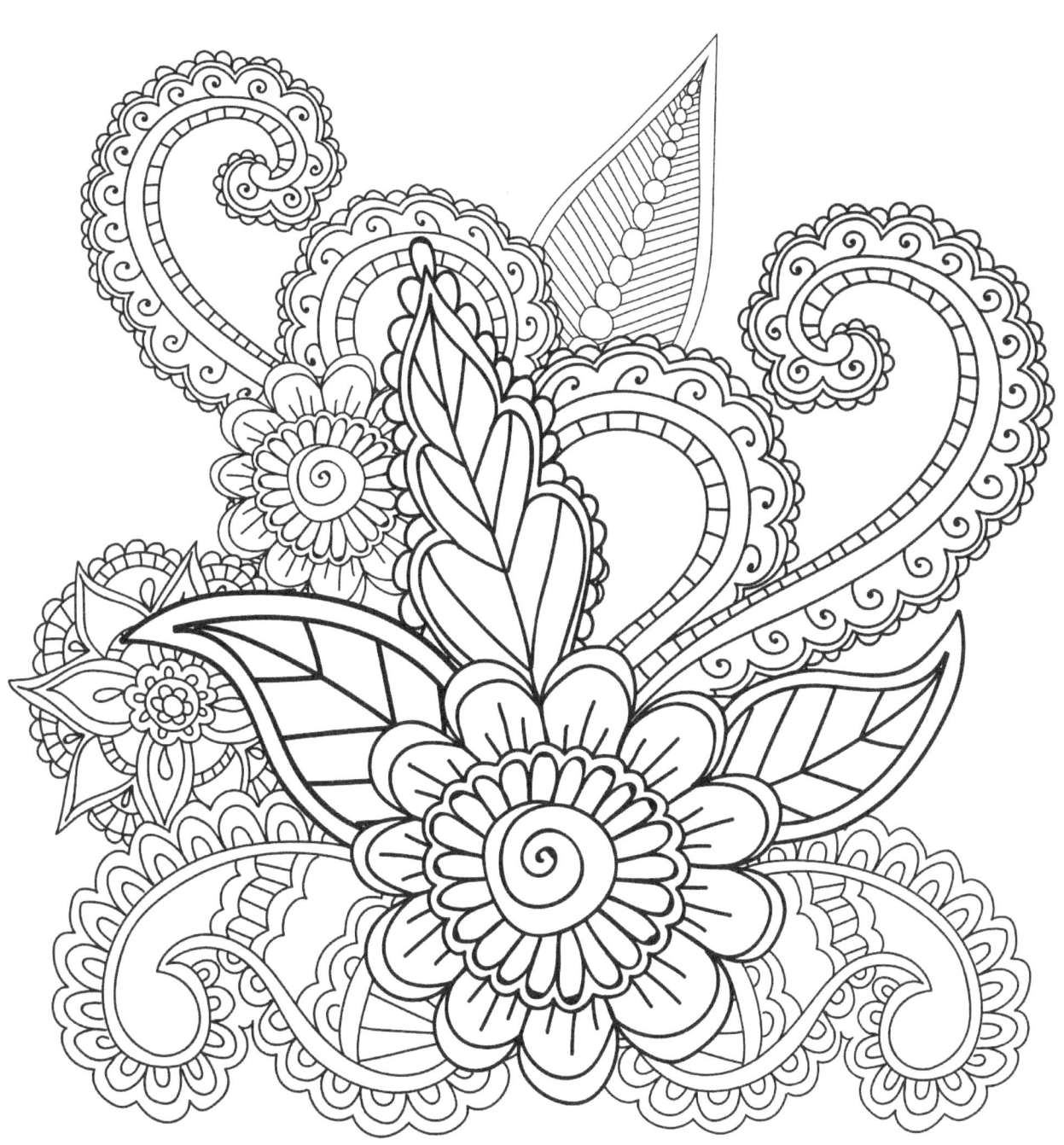

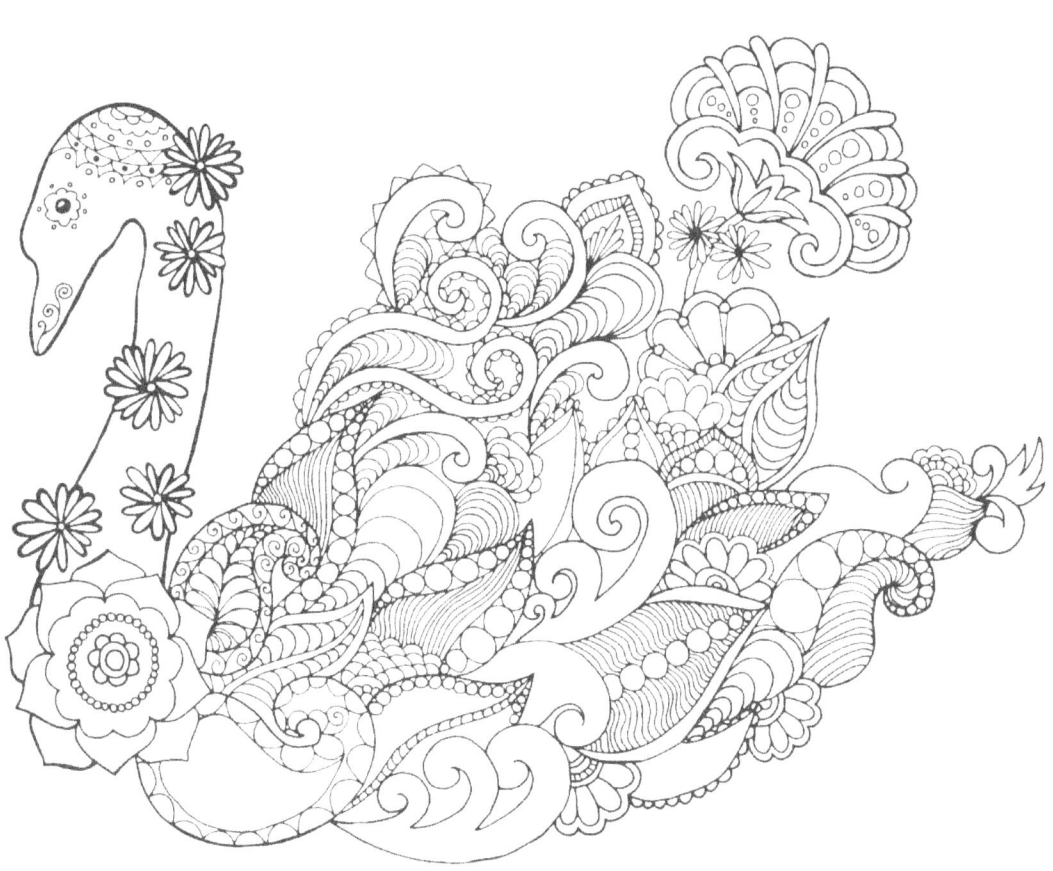

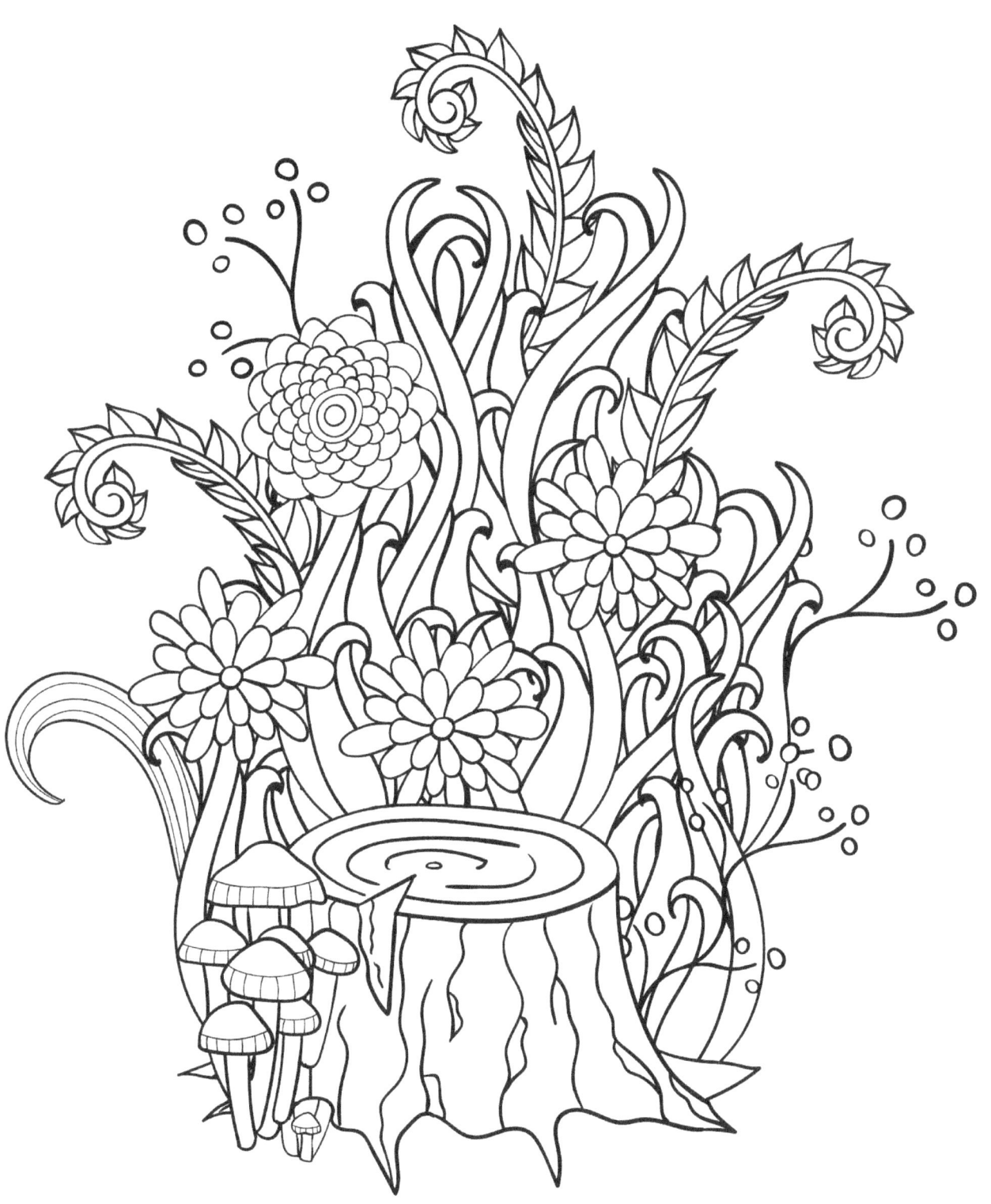

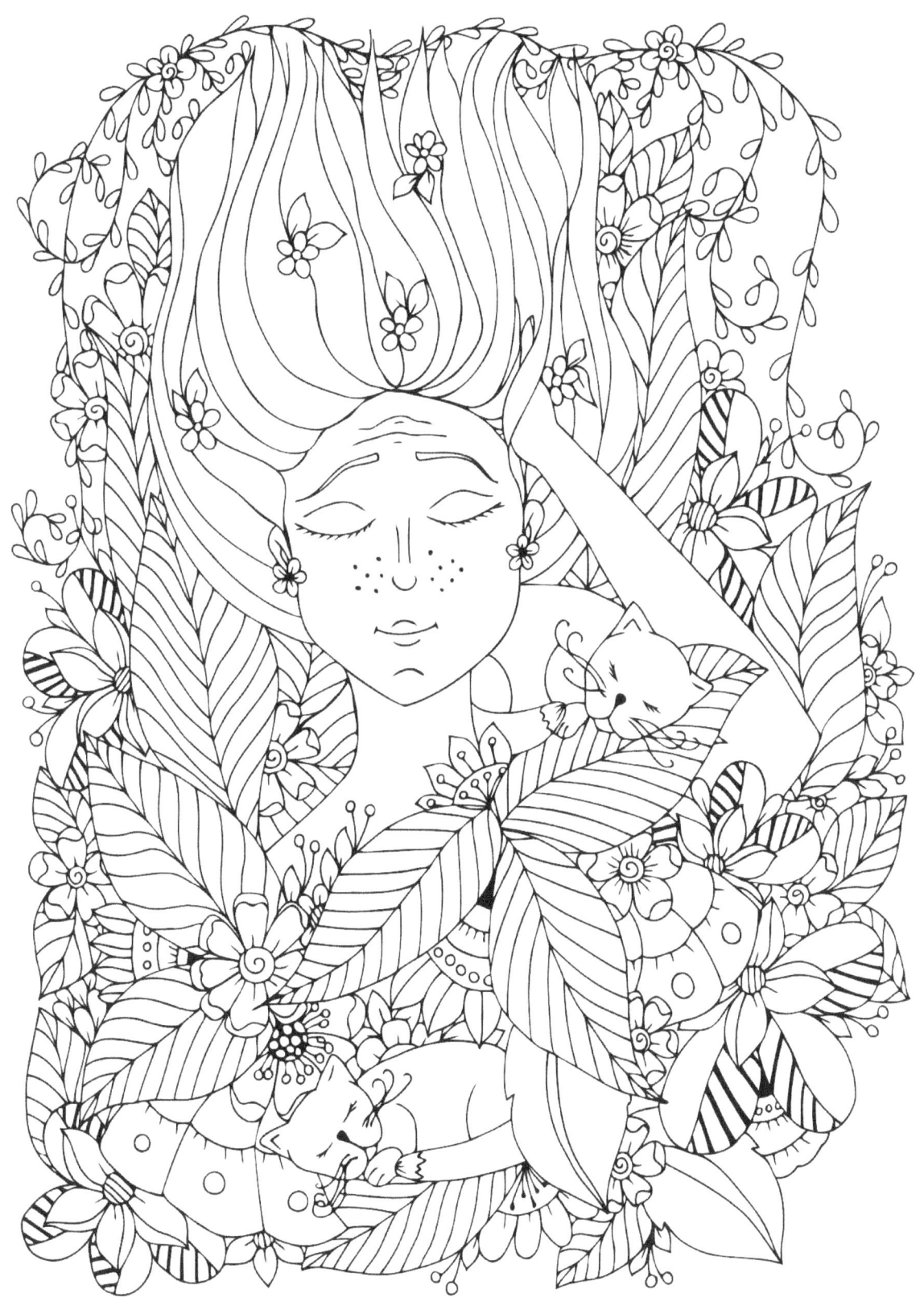

Color Art Designs

Hope you had fun with your coloring. This is the first book under this label. Look out for the next one which will be on coloring magnificent mandalas.

The coloring trend will remain popular because of its therapeutic benefits. So no matter your preferences you should be able to find many books to color.

Even though some designs may look similar the colored art will always be different because each person has a different style and choice of colors.

So go ahead create something new today.

www.ingramcontent.com/pod-product-compliance
Lightning Source LLC
Chambersburg PA
CBHW080541190526
45169CB00007B/2582